An exhibition organised for Atlantis Gallery
by Silvie Turner and Ian Tyson

British Artists' Books 1970-1983

Published by **Atlantis Paper Company**
Gulliver's Wharf, 105 Wapping Lane, London EI 9RW

Copyright © Silvie Turner & Ian Tyson 1984

First published 1984 by
Atlantis Paper Company Ltd
Gulliver's Wharf, 105 Wapping Lane, London E1 9RW

Distributed to the book trade by
Lund Humphries Publishers Ltd
26 Litchfield Street, London WC2

ISBN 0 85331 474 8

Designed by Herbert & Mafalda Spencer
Cover design by Ian Tyson
Photography by Colin Still (except for Cat. nos. 9, 14, 18, 25, 33)

Typeset by Katerprint Co Ltd, Oxford
Printed at The Camelot Press Ltd, Southampton

The exhibition 'British Artists' Books 1970–1983'
is at the following venues:

Atlantis Gallery
Gulliver's Wharf, 105 Wapping Lane, London E1 9RW
13 March–14 April 1984

Wingfield College
Wingfield, Eye, Suffolk
21 April–17 June 1984

Acknowledgements

Ian Tyson provided the original impetus for this exhibition and it was as a result of his knowledge, skills and insight that it took shape. A very constructive (and incidentally enjoyable) collaboration took place between Ian, Matthew Tyson (exhibition organiser) and Silvie Turner (catalogue editor), which provided the necessary coherent framework for such a challenging exhibition to be assembled. It is interesting to note that the most representative exhibition of British artists' books (*livres d'artiste*) held so far in this country can be viewed in the gallery of a paper company and it is Dave Brown and Stuart Welch of Atlantis Paper Company who must be warmly thanked for their bravery in backing the project and for agreeing to become publishers of a catalogue for the first time.

To the artists who kindly lent their works and especially those who agreed to allow their works to be handled we extend grateful thanks, and also to the publishers and galleries who lent work for this exhibition. Ron King (of the Circle Press) must be particularly thanked for his generous loans.

And finally, in their various fields, Colin Still who took the photographs, Laura Bamford and Lesley Ward who provided secretarial help, Michael Heseltine from Sotheby's who wrote the introduction and John Taylor at Lund Humphries Publishers must all be thanked for their appreciation of and enthusiasm for our project.

Introduction by Michael Heseltine

The field of fine illustrated books containing lithographs, etchings or woodcuts by major painters and sculptors has been dominated by the French artists this century since the first publications of Ambroise Vollard appeared just over 80 years ago. Vollard used his enormous flair, determination and financial resources not only to produce outstanding *livres de peintres*, but to establish a market for them. Since then many books of this type have been successfully published for an ever-growing circle of collectors, and it is now hard to believe that the 200 copies of Vollard's *Daphnis et Chloé* illustrated with lithographs by Bonnard and published in 1902 took 20 years to sell out.

In Britain during the same period the fine illustrated book developed along completely different lines for a very different market, although the quality of these publications often rivals that of the French books and similarly high sums are realised for some of them in the saleroom. Virtually all of these British books were produced by the private presses, particularly the Golden Cockerel Press in England and the Gregynog Press in Wales. The illustrators include Eric Gill, David Jones, and Paul Nash and many others who invariably used wood-engraving as their medium. Their work in this field was unrivalled by that of any other country, but most of the artists other than the three named were essentially illustrators. The painters and sculptors of the period rarely became involved in this type of book, perhaps because they were not prepared to spend time on the print-making techniques used so successfully by the French artists.

There are of course a few exceptions. Painters were occasionally commissioned to illustrate books, or chose to illustrate their own writings, but their drawings or paintings were invariably reproduced mechanically, as in the various books illustrated by Wyndham Lewis, the Bloomsbury painters, Michael Ayrton, John Minton, Graham Sutherland, and Rex Whistler. John Piper's *Brighton Aquatints*, 1939, is a solitary example of the modern English book illustrated with autographic prints. The same artist illustrated *English, Scottish and Welsh Landscapes* in the inexpensive and still under-rated 'New Excursions into English Poetry' series, 1944–47, comprising 7 volumes, each illustrated with 12 or 16 coloured lithographs by contemporary painters. A few years later Henry

Moore became the first major British artist to illustrate a French *livre de peintre* when he collaborated in the production of *Promethée*, which contains 14 coloured lithographs by him, published in 1950.

Then in the early 1960s a new generation burst on the scene. Print-making was encouraged in the art colleges; there was a return to figurative painting, much of it with a literary basis; and galleries opened to specialise in contemporary prints. In 1968 after some years of preparation Cavafy's *Fourteen Poems* appeared, illustrated with etchings by David Hockney. His established reputation did much to promote interest in the book and others recently published or in preparation. Ron King had by this time illustrated Chaucer's *Prologue* and *The Song of Solomon* with coloured screenprints and other publishers and presses were soon to be established. Ian Tyson started his Tetrad Press in 1969; Ann Brunskill's first publication from her Worlds End Press appeared in 1970; and Douglas Cleverdon returned to publishing with his Clover Hill Editions which include the Anthony Gross Theocritus of 1971 and the Michael Ayrton Verlaine of 1972, while other books were commissioned by the print galleries and publishers.

In some quarters there is still great reluctance to accept these books. Some readers consider them too large or awkward to handle, and print collectors may find the text an unnecessary encumbrance. However, the same could be said about some of William Blake's books, John Martin's *Paradise Lost* or Samuel Palmer's *Eclogues of Virgil*, all of which were illustrated with prints by painters – and which predate the French forerunners of the *livres de peintres*. The books in the present exhibition have been produced for the modern collector who is excited by the work of contemporary artists and has the bibliophile's traditional love of elegant typography, significant text and fine illustration united in one volume. The exhibition demonstrates the abilities of the printers and artists of this country, and will, one hopes, promote the recognition and appreciation they deserve.

'It was suggested that I might like to do a limited edition book. Laforgue seemed ideal.[*] I had first been introduced to his work by a fellow student at the Royal College of Art, in an English translation. His poetry had a detached romanticism and ironic humour that I felt an empathy with. Also, though I learnt that it had influenced many people, it seemed that there was very little published in translation, for those, like myself, who do not read French. Therefore, even a rather exclusive and limited publication I felt could introduce someone to the delights of Laforgue.

'I tried to add complementary images to the poems rather than "illustrations". I did this by imagining fictitious situations in which Laforgue might have conceived the poems. For example, knowing that he spent most of his short life in Germany, the line "Her handkerchief swept me along the Rhine" became the image of a hock glass with a napkin folded beside it, as in a restaurant. There is no logic in this, but it was a device to help me create the images. Taking this illogicality a step further, I used modern objects Laforgue could not have seen, in order to convey the timelessness of his poetry.

'The book itself is printed on a synthetic paper, the anonymity and coldness of which seemed to match the poems. I wanted the book to be bound in white, but was persuaded this was impractical. Later, I read in a recent biography that Laforgue had written to a friend that his next book would be bound in white "for this is my livery". So, I got it right, but didn't get it white.'

Patrick Caulfield

*The Poems of Jules Laforgue
(see Cat. no. 9)

British Artists' Books 1970–1983

W.J.Strachan, in the preface to his comprehensive study, *The Artist and the Book in France*, states that as yet the genre of the *livre d'artiste* 'has never been acclimatised in England'. We hope that this exhibition will show that, in fact, some of the finest examples of *livres d'artiste* published in the last fourteen years have been made within the United Kingdom. It is, however, true that this particular genre is comparatively little known or understood and almost unspoken of in this country. In the first place, therefore, it is to define and remind, to inspire and to look at what has been achieved in this area that we have devised this exhibition.

Livres d'artiste are books produced by artists in which the printed page is used as a medium for the artist's imagination. These books are quite distinct from other forms of publishing, for they are not tied to the conventions of literature or of illustration. We have displayed the books on view, therefore, in such a way that their unique quality as works of art may be appreciated. Looking at an artist's book does not involve instant gratification. It is not something that one can briefly contemplate over the breakfast table. There are a multitude of ways of looking and experiencing which artists' books explore; they ask to be looked at and read in a way that is totally different from the way in which a normal book is looked at and read. They propose ways of looking which take into account not only the logical structure of a book and the written language but also a plethora of visual experience. One cannot get away with a glance around the walls of *this* exhibition and a quick exit. The viewer is being asked to look at art in a new way, to explore these multiple levels of looking realised in the form of a book. An art gallery, such as Atlantis, is perhaps not an ideal context for viewing such works since a relationship with a book is often, and at its best, a private one. So it is to establish and to encourage this private interchange that we have, with the generous support of the majority of artists and publishers, devised a system whereby the books may be handled so that they can be examined in depth and in detail.

A second reason for wishing to organise an exhibition such as this is the lack of a comprehensive study of recent British *livres d'artiste*. This exhibition fills that

gap by presenting as fully as possible the work in this area accomplished since 1970. A limit of one book per artist, based on the artist's own choice, has been imposed. It is thus a non-selective exhibition and hopefully offers a representative picture of *livres d'artiste* made in the last fourteen years by British artists, produced in British workshops and backed by British publishers.

Because we inherit an imprecise description of a specific activity, it is necessary to define *livre d'artiste* here so that the boundaries and limitations of the exhibition can be clearly understood. *Livre d'artiste* is rather uncomfortably translated into English as 'artist's book', i.e. a book which has been made by an artist. Precise definition is elusive because in truth the *livre d'artiste* is something of a hybrid, at its best a visual '*Gesamtkunstwerk*'. A simple definition of a *livre d'artiste* would be an artwork which exists within the formal structure of a book and we have taken a book to mean any collection of pages in or out of sequence, usually held between covers. A more precise definition is a book which is produced with at least as much original visual content as text, where the intention has been to achieve and demonstrate a direct collaboration between writer, or editor in the case of an already existing text, and artist, and where an artist has been specifically commissioned to embellish that text through the medium of an autographic printing process. To quote W.J.Strachan again, 'The essential feature of the *livre d'artiste* is that each of the illustrations is an "original" and not a reproduction, i.e. artists have themselves executed their designs in one or other of the autographic media, although in many cases they are not the printers of the edition'. [1]

This makes it fairly obvious that the *livre d'artiste* cannot be confused with the *beau livre* (de luxe limited edition), the *livre de luxe* (any lavish production), 'artist's bookworks' or the 'fine printing' tradition of the private presses. It is an area where the considerations of commercial technology rarely apply. Most of the work is hand crafted (and we use the phrase with great care) and has nothing to do with the need for quantity. We are not denying the value of these other forms of book expression, but simply stating that the limits of this exhibition extend to cover only one aspect of the development of contemporary books, that of the *livre d'artiste*. By some, the *livre d'artiste* has tended to be regarded as an over-priced, over-rated, limited-editioned, extravagant luxury in which the content is disregarded in favour of the often splendid quality of production and binding. Simply to set matters straight in terms of the books in this exhibition, we would describe them as spanning a range from the '*luxeuse*' to the modest, from the traditional to the innovative, with a richness and diversity that is characteristic.

What makes an artist make a book? Often it is as easy and simple as a publisher's request. The decision to publish is, of necessity, a chicken and egg situation. The initial idea may emanate from a publisher who finds an exciting

text and wishes to match it to an artist's images. Alternatively, he may feel that a particular artist's work would translate well into book form and then try to find a suitable text. The real achievement in publishing artists' books comes from the editor/publisher's ability to 'introduce' the language and the images to each other, in other words to have that sixth sense which tells him that an artist will be sympathetic to a certain text, or that a writer will be interested in collaborating with a certain artist. The great publisher/editors were those who displayed this sixth sense to a high degree. Vollard's pairings, for example, were superb, as were those of Tériade and Iliazd, illustrating well that the role of publisher/editor has a unique and creative aspect of its own. One often finds resistance to contemporary texts, publishers believing that they will be able to sell more readily a book that has a text by an already established author. However, in the best works the illustrations integrate so finely with the text, and the poetry or prose so intensely illuminates the artist's work, that they cannot be separated from one another. It is the marriage of text and images, not the source, that is significant.

'Although I am a visual artist, I approached the book form as a writer. However, once I considered the text I had written as a printed book, I imagined the drawings as a visual counterpoint to the writing. I wanted to make it possible for someone to pick up the book and without reading a word get a feeling of the written text through the drawings. The book form being time based and kinetic, I imagined a graphic stream flowing from cover to cover.' This is a quotation from Liliane Lijn's description of *Crossing Map* (see Cat. no. 27).

In more recent times, as a result of economic restraints and cuts, publishers have become less willing to underwrite expensive productions. Perhaps partly as a result of this, a new trend has emerged from the traditional publisher/artist relationship, that of the one-man artist-publisher: and moreover, the concept of the artist in a do-it-yourself situation is becoming increasingly relevant to the younger artists who find difficulty in locating funding partners. The Circle and Tetrad Presses are prime examples of the success of the artist-publisher, but it is also necessary to consider the work of Natalie d'Arbeloff (Cat. no. 2), Ann Brunskill (Cat. no. 6) and Shirley Jones (Cat. no. 23), independent artists who do not rely on printers but are ably set up to produce and promote their own books. These artists (and the majority of artists in the exhibition) are in no sense professional book illustrators; their contribution to the book is in addition to their normal activities in painting, sculpture and printmaking, in which fields they have often made a national, and in some cases international, reputation. It is interesting to note on the other hand that a few of the artists represented have used the book almost exclusively as their media – Michael Caine (Cat. no. 7), John Christie (Cat. no. 10), and Ron King (Cat. no. 25).

It is worth mentioning here that a recurrent problem in the publishing of artists' books is the immense gap that has developed in Britain between the 'fine' and 'applied arts', a division which possibly bedevils British art more than that of any other nation. Painters and sculptors can be found who have little or no knowledge of what is termed 'graphics', and the idea that a well-designed page of type may be just as, if not more, rewarding and interesting than an inferior painting or sculpture is rarely entertained. The converse of this situation is also true incidentally – that many graphic designers remain ignorant of what fine artists' aims are or of their concerns as craftsmen. The well-designed and well-made book should help to resolve these differences and therefore provide an immensely rewarding synthesis of several visual and tactile experiences.

In embarking on a work an artist or publisher obviously considers the market forces that come into play. The price of many of these works (which can range from £15 to £10,000 though the average is somewhere between £100 and £400) has to do with the economics of investment and return, not simply with the exclusivity of a limited edition. Paper, printing, binding are all expensive and although in some cases it would be possible, once the print run was set up (if the plates or blocks would stand it), to print 1000 copies instead of 100, since there would be no guarantee of sales for such large numbers the artist or publisher must set a limit on how many he thinks he can sell. In France, the bibliophilic societies who commission books are able to relate the print run to the number of members who have taken out subscriptions.

One distinct advantage of a *limited* edition is that an artist can consider approaches that would be impossible with longer runs: such techniques as hand colouring; or those that are innovative, or difficult and time-consuming (such as intaglio, collage, etc.). Richard Wilson's book *Wind Instruments* (Cat. no. 45) is an example of another and exciting approach to the book form. Made in collaboration with Simon Cutts of the Coracle Press, it pushes the imagery into the three dimensional, extending the tactile experience.

Whilst discussing the question of costing (and incidentally human capacity) it seems pertinent to mention an exhibit that has caused recent controversy – *Dante's Inferno*, translated, illustrated and published by Tom Phillips and, at £10,000 per copy, the most expensive book in the exhibition (see Cat. no. 33).

'The Inferno comes in an edition of 180 of which 100 have already been sold: mental arithmetic might lead one to the conclusion that Tom Phillips was on his way to becoming a very rich man. That would, however, be a false assumption, because in order to raise the money to work on the book Phillips sold the first 60 copies in advance for £1,000 and the next 40 at a considerably reduced price. "I thought that would be enough," he explained, "but it actually cost me 150,000 nicker to do and another £100,000 in lost income over the

seven years I was working on it. I had to remortgage my house. I'll be lucky to break even." . . . there is nothing downhearted about his financial disappointments. "I always keep thinking that I'm on to a winner. That's another one of the illusions that sustains you, but I'm actually always on to a loser. I shall not be so naive and optimistic next time. I've learned a lot doing it – I could really do a book now. And since I've had to invent a press and it now exists I don't see why it shouldn't make more books."[2]

As *Dante's Inferno* suggests, time is at a premium in putting a book together and outworkers are often used to collate or bind or print by hand, thus increasing the unit cost. This might suggest that there is little scope for the *small* book of humble origin but those artist/printer/publishers of the 'do-it-yourself' variety are able, by their intimate knowledge of available materials, to make extremely interesting books of an innovative nature at a low cost (with the exception of time). A very good example of this kind of work comes from the Circle Press where Ron King's hand has guided many vastly different books through the presses including Michael Kidner's *The Elastic Membrane* (Cat. no. 24), Birgit Skiöld's *Tao of Water* (Cat. no. 39) and his own curious and haunting pop-up *Bluebeard's Castle*.

The production routine of a *livre d'artiste* often follows a classic pattern, involving many different branches of the applied arts, and the most satisfying books are those in which all the operations involved in the making have been successfully co-ordinated. The process may involve a typographer, a papermaker, a printer, a printmaker and a binder as well as the artist and the publisher and perhaps one of the greatest attractions of making a book is that it is in most cases a collaborative production. The very great artists' books have been an achievement of a perfect balance between all those involved. To make a binding of quality, for instance, requires the utilisation of specialist materials and time-consuming skills, and needs technical expertise as well as imagination. It is all too easy to produce bindings that are in many ways superior to the content of the book, but two individual binders whose superb work in the field of the *livre d'artiste* must be noted are Pella Erskine-Tulloch and Jane Rollo (see Tom Phillips' *Dante's Inferno* (Cat. no. 33) and Ian Tyson's *De Morandi* (Cat. no. 44)). They are both artist craftswomen in their own right, contributing their own self expression, often genuinely innovative, to the work as a whole.

Many artists' books have seemingly bypassed the modern movement in typography and adhered to an aesthetic set in the eighteenth century (for example, classic seriffed type faces, handmade paper with deckle edges, collectors' bindings, etc.). This may be due to the conservative taste of many bibliophiles pandered to by equally conservative publishers, or perhaps there are other reasons why it is difficult within the genre to avoid the classic mould.

The handmaking of books presents only one aspect of the possible varieties of production. There exists no doubt that the criteria referred to earlier could be applied to sophisticated mass production too. For example, Eduardo Paolozzi's *General Dynamic F.U.N.* (Cat. no. 31) is almost entirely photomechanical but could only have been produced as a result of intimate collaboration between artist and printer; in no way can the work be described as a 'reproduction' as there are no originals. There are many bibliophiles who will not accept this type of work as evidence of true originality of intent, '*à la main*' being the battle cry, but the question really is whose '*main*' and when does it manifest itself in the process? Originality in the printing process is largely conceptual; even Maillol did not cut the blocks for his woodcut books (Ovid, *Daphnis et Chloé*) himself and neither did the artists who made the images for the eighteenth- and nineteenth-century Japanese books which are so much admired.

The gradual development of the *livre d'artiste* from illustrated book means that we have to try to elucidate that very grey area between the two. It is all very well to have an instinctive 'feeling' that one is a *livre d'artiste* and the other not but this can easily be conditioned by prejudice and/or predilection. Matisse explained it very well when he said in a conversation: 'I agree with your distinction between the illustrated and the decorated book. A book should not need completion by an imitative illustration. Painter and writer should work together without confusion, on parallel lines. The drawings should be a plastic equivalent of the poem. I wouldn't say first violin and second violin, but a concerted whole.'[3] The fact remains that the *livre d'artiste* is a book in which the images are produced autographically by the artist with or without expert technical assistance from a printer and are a complementary element to the text. The illustrated book on the other hand contains images which may be merely photomechanical reproductions of the artist's work. Often the *raison d'être* of a *livre d'artiste* may be that of intention as much as of execution.

Perhaps it is also worth mentioning here categories that have quite deliberately been excluded. In recent years a category called 'artists' bookworks' has emerged and proliferated bringing new sets of definitions that have grown out of the context in which they are viewed. They have evolved alongside other 'alternative' or communications media – video, performance art, happenings, fluxus – and are extensions of the area in which an artist uses a book as an art object and which has been made in thousands of copies, in hundreds or even in single items. These works are often inexpensive, produced as completely autonomous art forms, but do not concern the boundaries of this exhibition.

This does not imply that the *livre d'artiste* always achieves perfection; in fact many examples fall short of what might be attained. The relationship of image and text should be one of complete formal composition from one page to another and from title page to colophon so that it should be possible to look

through the book as if it were transparent. To quote Léger's experience of making a book 'as page succeeds page, the plates turn like spokes of a wheel. Space is curved, like the earth and everything around us.'[4] Or again 'it is partly the sequential nature of the book that interests me, the conception of the pages being each one a facet of the whole and that of the work being slowly revealed as one moves from one to the other', to quote Ian Tyson.[5]

There is no apparent diminution of the quality or variety of *livres d'artiste* in this exhibition and by careful consideration one's eyes may be opened to a media that will have the effect of increasing one's sensitity to an artists' particular aims, to words, exploring beyond the conventions of reading matter and the rational two dimensions of the printed page. We hope that the future will see more of the evolution and development of the *livre d'artiste* and that accessibility, one of our main aims, will be easier. So we urge collectors to exhibit their collections, urge interested public to seek out publishers, invite galleries to offer more space so that one may enjoy the experience of a book as an intimate, entirely personal and often at best a private experience.

Silvie Turner
Ian Tyson

References

1. W.J.Strachan *The Artist and the Book in France* Peter Owen, London 1967
2. The Sunday Times, 30 October 1983 'The Phillips Inferno. . .' by David Thomas.
3. Matisse in conversation with Raymond Escholier in *Matisse from the Life*, 1956.
4. Extract from Fernand Léger in catalogue *Hommage à Tériade*, Royal Academy of Arts, London 1975.
5. Extract from letter from Ian Tyson to Silvie Turner, December 1983.

Bibliography

Catalogues

Artists' Books Arts Council of Great Britain
 1976

Artists' Bookworks Fine Art Department
 British Council
 1975

The Artist and the Book in England Morley Gallery, London
 1971

The Artist and the Book in France from Playhouse Gallery, Harlow
the collection of W.J.Strachan 1981

Books by Artists Art Metropole, Canada
 1981

Book Works South Hill Park Arts Centre, Bracknell
 1981

Chillida. L'Oeuvre Graphique Maeght Editeur, Paris, France
 1978

Écritures Fondation Nationale des Arts
 Graphiques et Plastiques, Paris, France
 1980

Hommage à Tériade Royal Academy of Arts, London
 1975

Künstlerbücher Galerie Lydia Megert, Bern, Switzerland
 1979

Le Livre et L'Artiste 1967–76 Bibliothèque Nationale, Paris, France
 1977

Libra Artista Metronom, Barcelona, Spain
 1981

The Open and Closed Book Victoria and Albert Museum, London
 1979

Printed at Watford Hansjorg Mayer and Watford School of
 Art

Books 1974

The Artist and the Book in France, Peter Owen, London
by W.J.Strachan 1967

Catalogue

1
Norman Ackroyd
Travels with Copper + Zinc

Published in 1983 by
Penny Press
23 Clapham Manor Street,
London SW4

Edition of 20 copies + 3 artist's proofs

Author: the artist
Printed by Allan Smith and the artist

300 × 250 mm
23 pages, 16 full-page etchings. Loose
bound in folder + slipcase

2
Natalie d'Arbeloff
Seuphor à Natalie

Published in 1978 by
Natalie d'Arbeloff Press
6 Cliff Villas, London NW1 9AL

Edition of 45 copies

Author: Extracts from letters written by
Michel Seuphor to Natalie d'Arbeloff in
1973–74
Printed by Edward Ash

220 × 330 mm
Text in French & English with 8 inkless
intaglio images by the artist. French text
hand-printed on etching press by the
artist, from blocks made from the letters
in Seuphor's hand, enlarged. English text
handset, 12pt Grotesque.
7 double sheets + title page wrapped
around inserted into dark blue folders

with two of the letters/blocks blind
embossed on front and back. Contained
in red cloth-covered slipcase

3
John Bellany
A Celtic Quintet, 39/50

Published in 1983 by
Balbirnie Editions
Balbirnie Burns East Cottage
Fife, Scotland

Edition of 50+1 printer's proof + 4
artist's proofs, signed and numbered by
the artist and author on title page, each
image signed by the artist

Author: Alan Bold
Printed by Alfons Bytautas, Printmakers
Workshop and John Ward, Albion Press,
Edinburgh College of Art

390 × 300 mm
12 pages, 5 full-page and 5 half-page
illustrations, printed on Somerset TP
300gsm, text set in Perpetua Italic printed
by letterpress, illustrations printed by
sugar aquatint, in a buckram folder by
Rafe Fleming

4
Pip Benveniste
Link Link

Published in 1977 by
The Arc Press (now known as Arc &
Throstle Press)
Waterside Mill
Rochdale Road, Todmorden, Lancs

Edition of 125 copies, numbered, 10
signed by the artist

Text by Bashō
Printed by Tony Ward and bound by
Tony Ward and the artist

140 × 110 mm
21 pages, 18 full-page plates. Concertina
pull out, wrap around jacket (fixed)

5
Ian Breakwell
Ten Diary Pages 1969–82

Published in 1983 by
Printmaking Department
Norwich School of Art

Edition of 50 copies

Author: the artist
Printed by Mel Clark

345 × 255 mm
10 pages, 10 full-page illustrations.
Loose in folder

6
Ann Brunskill
Thomas Traherne

Published in 1979–80 by
Worlds End Press, Star & Garter Lane
Egerton, Ashford, Kent

English edition of 50 copies (text in
letterpress)
American edition of 100 copies (text in
litho)

Author: Thomas Traherne
Printed by Ann Brunskill, Lindsey
McGarrity, Jonathan Parkinson

470 × 330 mm
40 pages, 8 full-page illustrations (7 coloured woodblock, 1 etching), in yellow linen box lined blue, screenprinted with title in black (10 folios in dark blue paper wrapper)

7
Michael Christopher Caine
The Blue Dream (Le Rêve Bleu)

Published in 1981 by
the Artist
9 Brocket House, Union Road
Stockwell, London SW8 2RE

Edition of 15 copies

Author: Louis Aragon
Printed by the artist

250 × 325 mm
8 loose pages, 6 half-page woodcut (pine & mahogany) illustrations, text woodcut, printed on Velin Cuvee BFK Rives, dedication and imprint pages on Barcham Green Badgers Lilac HM paper

Two copies quarterbound in tan leather (Oasis morocco) and coloured parchment; twelve copies in plain black cloth chemise, with title pasted down on spine; all copies in slipcases

8
Ken Campbell
Father's Hook

Published in 1978 by
the Artist
6 Danvos Road, London N8 7HH

Edition of 100 copies signed by the artist

Author: the artist
Printed by the artist

330 × 165 mm
24 pages, 8 full-page illustrations printed by letterpress/lino, text printed by letterpress; Chinese binding and handsewn with 'invisible' thread contained between 6 mm birch plywood; secured with a thick rubber band

9
Patrick Caulfield
The poems of Jules Laforgue

Published in 1973 by
Petersburg Press (in association with Waddington Galleries)
9a Portobello Road, London W11

Edition:
a. 200 copies + 20 proofs: poems in English, 22 illustrations plus 6 loose prints
b. 200 copies + 20 proofs: poems in French, 22 illustrations plus 6 loose prints
c. 100 copies + 20 proofs: poems in English, 22 illustrations plus 22 loose prints

Author: Jules Laforgue
Printed by Chris Betambeau and Frank Kicherer

405 × 355 mm
56 pages, plus 6 loose sheets; 22 plus 6 full-page illustrations; text and illustrations screenprinted

a. Book and 6 loose prints in a portfolio; together in a slipcase: all three bound in grey leather
b. As for edition (a), but bound in a different grey leather
c. Book in a leather slipcase, and 22 loose prints in a separate box: both in a different grey leather

10
John Christie
Between the Dancers

Published in 1980 by
Circle Press
22 Sydney Road, Guildford, Surrey

Edition of 80 numbered copies signed by the poet and the artist + 10 artist's proofs

Author: Ken Smith
Printed by the artist

330 × 260 mm
36 pages, 6 full-page illustrations (screenprinted), text handset in 14pt Optima and printed letterpress on Somerset 250gsm rag paper, hardbound in a slipcase by Dorset Bookbinding Company

11
Anthony Davies
Peter Grimes

Published in 1982 by
Clare Beck and Moira Kelly Fine Arts

Edition of 50 copies + 10 artist's proofs

Author: George Crabbe
Printed by Print Workshop and Circle Press

395 × 365 mm
62 pages, 22 full-page illustrations (etchings and aquatints), text by letterpress, printed on 300gsm Saunders Rag-made paper, loose bound in slipcase and cover

12
David Davies
Norfolk Curios

Published in 1981 by
the Artist
166 King Street, Norwich,
Norfolk NR1 1QH

Edition of 6 copies

Author: the artist
Printed by the artist

380 × 570 mm
11 pages, 10 full-page illustrations (326 × 248 mm), text and illustrations etchings, clothbound in a library-style binding

13
Julia Farrer
Les Prunelles de la Libellule

Published in 1978 by
the Artist
41 Melgund Road, London N5 1PT

Edition only in proof (1980): size of edition undecided

Author: Japanese authors translated by Maurice Coyald
Printed by the artist

170 × 540 mm
8 pages, 8 full-page illustrations, text and illustrations etchings, in a paper folder

14
Elisabeth Frink
The Canterbury Tales

Published in 1972 by
Leslie Waddington Prints
34 Cork Street, London W1

Edition:
1 50 copies, edition de tête, numbered
A1 – A50
2 50 copies, standard edition, numbered
B51 – B100
3 175 unbound copies, numbered
C101 – C275
4 25 hors commerce copies, numbered
D276 – D300
The 19 illustrations were also published
as a set of etchings (in an edition of 50) in
a specially made box.

Author: Geoffrey Chaucer, ed. Professor
Nevill Coghill
Printed by Cliff White and Hillingdon
Press

655 × 460 mm
192 pages, 19 full-page illustrations
(etchings), text by letterpress

1 Handbound, full binding in English
hide, in a slipcase
2 Handbound, full binding in Coverex kid
grain, in a slipcase
3 Loose sheets, boxed in a portfolio
4 Loose sheets, boxed in a portfolio

15 (not illustrated)
John Furnival
Blind Date

Published in 1979 by
Circle Press
22 Sydney Road
Guildford, Surrey

Edition of 300 copies + 30 artist's proofs

Author: Thomas Meyer
Printed by Circle Press (letterpress text)
and Jack Shirreff (etchings and reliefs)

280 × 300 mm
60 pages, 11 full-page etchings and relief
prints. Loose folios contained in a case
and slipcase

16
Derrick Greaves
Also

Published in 1972 by
Tetrad Press
148 Narrow Street, London E14

Edition of 100 copies

Author: Roy Fisher
Printed by Kelpra Studio Ltd

470 × 650 mm
7 pages, 7 full-page illustrations, text and
illustrations silkscreened, wrap-around
printed sleeve white on white in brown
slipcase

17
Anthony Gross
The Very Rich Hours of Le Boulvé

Published in 1980 by
Rampant Lions Press
12 Chesterton Road, Cambridge

Edition of 120 ordinary copies, signed +
15 special copies with an extra set of
plates and an original drawing

Author: the artist
Printed by Will and Sebastian Carter
(letterpress) and the artist and
Mary West (plates)

325 × 250 mm
112 pages, 21 full-page and 5 half-page
illustrations (intaglio: etchings and
engravings), text by letterpress, ordinary
edition quarterbound in leather and cloth,
special edition bound in full morocco with
solander box

18
S W Hayter
Death of Hektor

Published in 1979 by
Circle Press, Guildford, Surrey and
Sovereign American Arts, New York

Edition of 300 copies + 30 artist's proofs

Author: Brian Coffey
Printed by Jack Shirreff and
Michael Gray

400 × 320 mm
42 pages, 8 full-page and one double
spread illustrations (etchings), text by
letterpress, loose-board cloth cover and
slipcase

19
Patrick Heron
The Shapes of Colour

Published in 1978 by
Kelpra Editions Ltd
19 Bath Street, London EC1

Edition of 50 copies + 10 artist's proofs

Author: the artist
Printed by Kelpra Studio Ltd

500 × 350 mm
40 pages, 23 full-page illustrations
(screenprinted), casebound with slipcase

20
Gordon House
An Assemblage of Several Things

Published in 1978 by
Kelpra Editions Ltd
19 Bath Street, London EC1

Edition of 50 copies + 10 artist's proofs

Author: the artist
Printed by Kelpra Studio Ltd

500 × 350 mm
31 pages, 28 full-page illustrations
(screenprinted), casebound with slipcase

21
William Johnstone
William Johnstone, Edwin Muir

Published by
Mary Johnstone
Palace Crailing,
Jedburgh, Roxburghshire

Edition of 50 signed and numbered folios,
each image signed by the artist

Author: Edwin Muir
Printed by Ken Duffy (Printmakers
Workshop), Pillans & Wilson, Edinburgh

26 pages, 20 full-page illustrations +
1 double spread (direct lithography), text
by letterpress, leather presentation folder
by Sandy Lumsden, Loanhead

22
Allen Jones
Ways and Means

Published in 1978 by
Kelpra Editions Ltd
19 Bath Street, London EC1

Edition of 50 portfolios + 10 artist's
proofs

Author: the artist
Printed by Kelpra Studio Ltd

500 × 350 mm
16 pages, 30 full-page illustrations
(screenprinted), casebound with slipcase

23
Shirley Jones
Scop Hwīlum Sang

Published in 1983 by
the Artist
Red Hen Press
2 Croham Park Avenue
South Croydon CR2 7HH

Edition of 50 prints of which the first 25
appear with text as bound or unbound
books

Author: the artist
Printed by the artist

360 × 300 mm
16 pages, 7 full-page illustrations
(etchings), text set in Baskerville, bound in
leather with cloth-covered boards printed
by the artist. Endpapers in Fabriano
cover. Presented in matching drop-back
box

24
Michael Kidner
The Elastic Membrane

Published in 1979 by
Circle Press, Guildford, Surrey and
Sovereign American Arts, New York

Edition of 300 copies + 35 artist's proofs
+ 10 marked I–X for Circle Press + 5 HC

Author: the artist
Printed by Jack Shirreff and
Barry Millard

350 × 450 mm
One object (stretched elastic on board),
six prints, two notebooks; illustrations
photo etching and photo litho, text photo
litho. A wooden box with clear perspex
cover inscribed with the title and revealing
a stretched elastic object inside the box

25
Ron King
White Alphabet

Published in 1983 by
Circle Press
22 Sydney Road, Guildford, Surrey

Edition of 200 copies

Author: the artist
Printed by the artist

290 × 135 mm
56 pages, blind intaglio and letterpress
text on 120lbs RLS HM rough paper,
concertina construction, in a soft cloth
slipcase

26
Willow Legge
An African Folktale

Published in 1979 by
Circle Press, Guildford, Surrey
and Sovereign American Arts,
New York

Edition of 200 copies + 30 artist's proofs

Author: anonymous
Printed by Willow Legge and John
Coleman

400 × 320 mm
36 pages, 9 full-page and 3 half-page
illustrations blind embossed + silkscreen,
text printed letterpress in Baskerville, on
Somerset 300gsm Rag-made paper.
Loose bound in solander box

27
Liliane Lijn
Crossing Map

Published in 1983 by
Thames and Hudson
30–34 Bloomsbury Street,
London WC1B 3QP
(by arrangement with Edition Hansjorg
Mayer, Stuttgart)

Edition of 75 copies

Author: the artist
Printed by Staib & Mayer, Stuttgart

240 × 180 mm
160 pages, 150 full-page illustrations and
text printed by offset lithography. Each
set comes in a cloth bound slipcase. It
contains a signed and numbered copy of
the book Crossing Map printed in
graphite on a cream paper and 16
leporello lithographic prints on Fabriano
paper, each separately titled, signed,
numbered and dated. The prints are
separated into four sets in numbered cloth
bound chemises

28
Katrina Longden
Three Wishes

Published in 1983 by
the Artist
17 Hayter Road, Brixton Hill,
London SW2

Edition of 50 copies, 25 of which are
hand-coloured

Author: the artist
Printed by the artist

295 × 165 mm
6 pages, 12 full-page illustrations (wood
engravings), text by letterpress, wrap-
round paper cover

29
Mary Jo Major
Poemprints

Published in 1980 by
Omlette Press
18 Phipp Street, London EC2

Edition of 42 copies

Author: Faith Gillespie
Printed by the artist and Faith Gillespie

355 × 274 mm
13 folded pages, 12 full-page illustrations,
10 poems set in Centaur, printed on
Richard de Bas Handmade paper, in a
slipcase

30
Robert Medley
Samson Agonistes

Published in 1979 by
Medley/Clark, London

Edition of 150 copies

Author: John Milton
Printed by Mel Clark

350 × 280 mm
46 pages, 24 full-page illustrations
(screenprinted), text by lithography,
hardbound in fawn cloth with loose
dustcover

31
Eduardo Paolozzi
General Dynamic F.U.N.

Published in 1970 by
Editions Alecto Ltd
27 Kelso Place, London W8

Edition of 350 copies, 6 signed on the 50
images, title of each print stamped on the
back
Printed by Editions Alecto/Richard Davis
Ltd

400 × 280 mm
54 pages, 44 full-page and 6 half-page
illustrations, text and illustrations photo
litho and screenprinted, loose prints in
perspex box

32
Victor Pasmore O.M.
The Image in Search of Itself

Published in 1977 by
Kelpra Editions Ltd
19 Bath Street, London EC1

Edition of 50 copies + 10 artist's proofs

Author: the artist
Printed by Kelpra Studio Ltd

500 × 350 mm
23 pages, 18 full-page illustrations
screenprinted, casebound with slipcase

33
Tom Phillips
Dante's Inferno

Published in 1983 by
The Talfourd Press
57 Talfourd Road, London SE15

Edition of 185 copies in all, divided as
follows: 10 edition de luxe: 26 copies of
standard edition for subscribers, and a
further 100 copies of standard edition for
general sale: 10 artist's proofs: 17
(maximum) hors commerce copies and
two archive copies

Author: Dante Alighieri
(new translation into English by the artist)
Printed by I.M. Imprimit (text), Talfourd
Press (intaglio), Dogs Ear Press
(lithographs), Advanced Graphics &
Coriander Press (silkscreens)

420 × 315 mm
432 pages, 138 full-page illustrations
(intaglio, lithography, silkscreen), text by
letterpress. Standard edition presented in
two buckram case boxes. Standard de
luxe binding (3 volumes in a slipcase) by
Pella Erskine-Tulloch: described in full in
Waddington Galleries book prospectus

34
Richard Pinkney
Spare Parts

Published in 1971 by
Tetrad Press
148 Narrow Street, London E14 8BP

Edition of 75 copies with 5 artist's proofs

Author: the artist
Printed by Kelpra Studio Ltd

280 × 260 mm
9 pages, 9 full-page illustrations, text and
illustrations screenprinted on
J Green Mouldmade Paper, sheets
combined in paper wrappers

35
John Piper C.H.
Stones and Bones

Published in 1978 by
Kelpra Editions Ltd
19 Bath Street, London EC1

Edition of 50 copies + 10 artist's proofs

Author: the artist
Printed by Kelpra Studio Ltd

500 × 250 mm
18 pages, 33 full-page illustrations
screenprinted, casebound in slipcase

36
Patrick Procktor
The Rime of the Ancient Mariner

Published in 1976 by
Editions Alecto Ltd
27 Kelso Place, London W8

Edition of 100 copies with 25 special
books containing 4 loose aquatints

Author: Samuel Taylor Coleridge
Printed by Tisiphone Etching + Rampant
Lions Press

360 × 280 mm
33 pages, 12 full-page illustrations
(aquatints), text printed by letterpress,
bound book with screenprinted cover

37
Alan Reynolds
Six Poems of the Tang Dynasty

Published in 1970 by
Circle Press
22 Sydney Road, Guildford, Surrey

Edition of 25 copies + 5 artist's proofs

Author: from the Chinese, translated by
Michael Bullock and Jerome Ch'en
Printed by Alan Reynolds and Ronald
King

550 × 370 mm
46 pages, 7 full-page illustrations (lino or woodblock), text by letterpress, binding Keypoint Francke slipcase + cover 240lbs J Greene Mouldmade paper, separate prints in loose sections

38
Michael Rothenstein
Suns and Moons

Published in 1972 by
Rampant Lions Press
12 Chesterton Road, Cambridge

Edition of 85 signed copies

Author: various (anthology)
Printed by Sebastian Carter (text) and the artist and Shelley Rose (prints)

555 × 380 mm
52 pages, 8 full-page illustrations (woodcut + assemblages printed letterpress), text printed letterpress, loose sheets laid in box

39
Birgit Skiöld
Tao of Water

Published in 1979 by
Circle Press, Guildford, Surrey and Sovereign American Arts, New York

Edition of 200 copies + 20 artist's proofs

Author: James Kirkup
Printed by Print Workshop and Circle Press

255 × 255 mm
40 pages, 8 full-page illustrations (lithography and blind embossed etchings), text by letterpress, printed on Arches Blanc 250gsm Cuvé, in a solander box

40
Keir Smith
Ceres

Published by
the Artist
39 Lewis Road, Istead Rise, Northfleet, Kent OA13 9JQ

Edition of 25 copies

Author: the artist
Printed by Ithaca Press (text) and the artist

330 × 200 mm
20 pages, 15 full-page illustrations (fire, print and brand), text by letterpress, clothbound portfolio

41
John Tetley
Studley Royal, Surprise Views over Lorraine

Published in 1981 by
New Arcadians
40 North View, Wilsden, Bradford, West Yorkshire

Edition of 100 copies

Author: Patrick Eyres
Printed by the artist

430 × 310 mm
37 pages, 37 full-page illustrations, text and illustrations printed by lithography, presented in a folio

42
Jake Tilson
The V Agents

Published in 1981 by
The Woolley Dale Press
44 Broomwood Road, London SW11

Edition of 50 copies

Author: the artist
Printed by Letterstream (1981), London

9¾ × 6¼ in.
25 pages, 24 full-page illustrations (colour and black and white Xerox), spiral binding, hand-tipped images

43
Joe Tilson
Alchera: Notes for Country Work, 1970—74

Published in 1977 by
Kelpra Editions Ltd
19 Bath Street, London EC1

Edition of 50 copies + 10 artist's proofs

Author: the artist
Printed by Kelpra Studios Ltd

500 × 350 mm
18 pages, 33 full-page illustrations (screenprinted), casebound with slipcase

44
Ian Tyson
De Morandi

Published in 1979 by
Circle Press
22 Sydney Road, Guildford, Surrey

Edition of 300 copies + 30 artist's proofs +15 marked H/C (10 for presentation)

Author: Kevin Power
Printed by C. Mitchell Ltd (letterpress); Studio Prints, London (aquatints)

390 × 300 mm
22 pages, 8 full-page illustrations (blind aquatints), text by letterpress, case holding loose folios in slipcase made by Dorset Bookbinding Company Ltd

45
Richard Wilson
Wind Instruments

Published in 1980 by
the Artist and Coracle Press
233 Camberwell New Road, London SE5

Edition of 125 copies + 35 artist's proofs

Author: the artist
Printed by Coracle Press

470 × 330 mm
16 pages, 5 full-page and 6 half-page illustrations, 7 sculptures (wood wire Japanese *gampi* tissue). 'Chestnut box' containing 7 sculptures laid in trays of paper made by Georges Duchêne at Couze, France

1 Norman Ackroyd

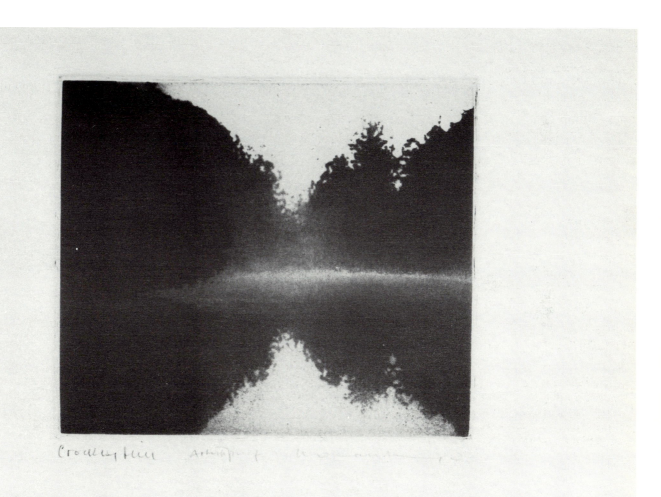

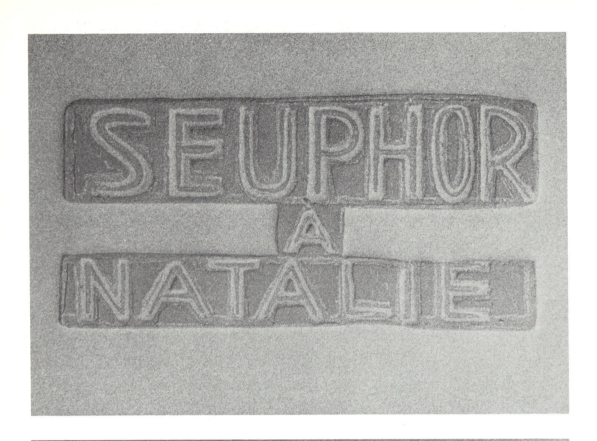

A CELTIC QUINTET

JOHN BELLANY & ALAN BOLD

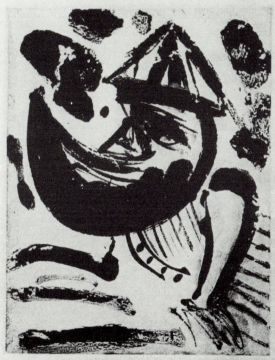

Entrance

His child releases him from adulthood,
He throws his inhibitions to the wind.
He gurgles with the baby, plays with toys,
Comes back to earth feet first, grasping the ground.
He sleeps the baby, spoons the baby food,
Performs for it, makes faces with his hands.
The baby nods and, nodding, understands.
For many months the father is fulfilled.
His day is something he gets over with.
He rushes home with water on his mind:
He'll plunge the baby in his nightly bath.
They soak so long the bathwater is chilled;
He gently lifts the baby, rubs him dry,
Acknowledges the laughter in his cry.

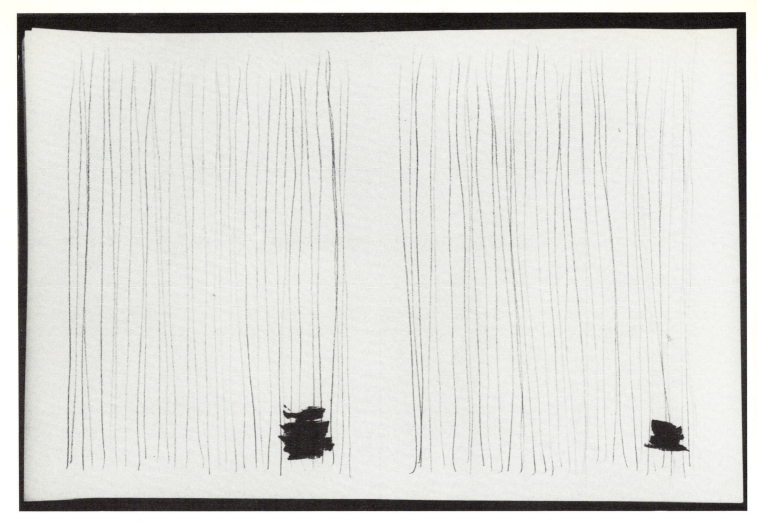

4 Pip Benveniste

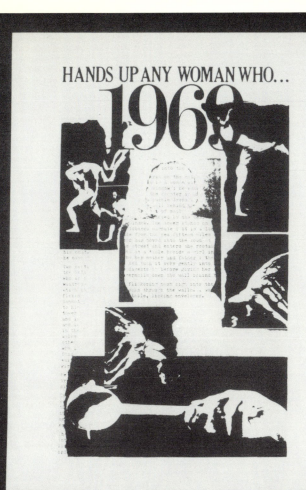

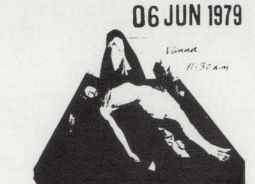

5 Ian Breakwell

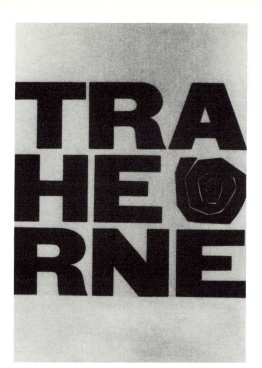

5

Being thus prepard for all Felicity,
Not prepossest with Dross,
Nor stifly glued to gross
And dull Materials that might ruine me,
Not fetterd by an Iron Fate
With vain Affections in my Earthy State
To any thing that might Seduce
My Sence, or misemploy it from its use:
I was as free
As if there were nor Sin, nor Miserie.

6

Pure Empty Powers that did nothing loath,
Did like the fairest Glass,
Or Spotless polish Brass,
Themselvs soon in their Objects Image cloath.
Divine Impressions when they came,
Did quickly enter and my Soul inflame.
Tis not the Object, but the Light
That maketh Heaven; Tis a Purer Sight.
Felicitie
Appears to none but them that purely see.

Ils sont
juste en train
de voler les
cerises
Je prends
des épingles
sur la pelote
D'épingles

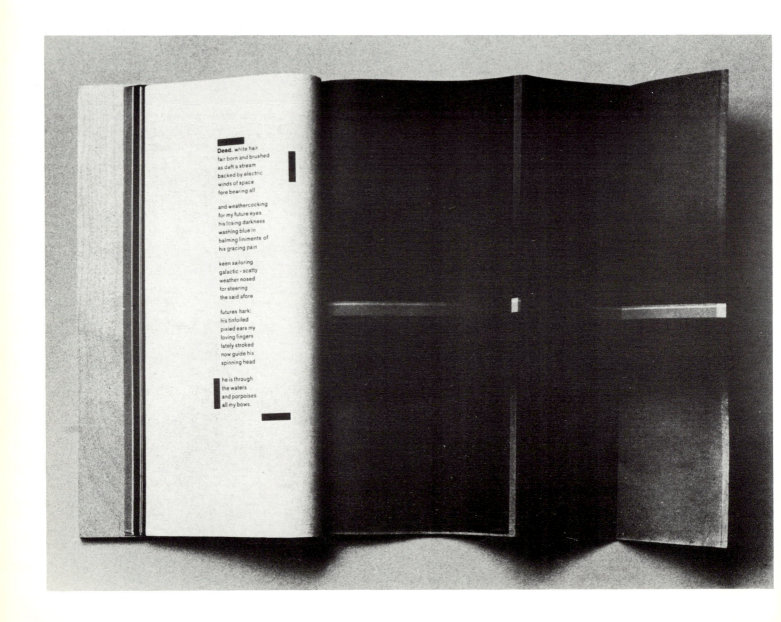

Dead. white hair
fair born and brushed
as daft a stream
backed by electric
winds of space
fore bearing all

and weathercocking
for my future eyes
his losing darkness
washing blue in
balming liniments of
his gracing pain

keen sailoring
galactic - scatty
weather nosed
for steering
the said afore

futures hark:
his tinfoiled
pixied ears my
loving fingers
lately stroked
now guide his
spinning head

he is through
the waters
and porpoises
all my bows.

Moonrise,
O road in dream surprised! . . .
We've passed the spinning-mills and sawmills,
Nothing but milestones now;
Little clouds of confectioner's rose

Where a slender crescent of moon arose,
O dreaming road, O silent music . . .
In this pine wood which knows,
Since the world's beginning,
Only the night,
So many clean, deep chambers!
Oh! to elope for a night!
And I people them, and I see myself there,
And lovers, a handsome pair,
Gesticulate lawlessly.

And I pass by and leave them,
And lie down facing the sky.
The road turns, I am Ariel,
No one waits for me, I'm going to no one's home.
I've only the friendship of hotel rooms.

The moon rises.
O road wrapped in dream,
O road without end,
Here is the inn
Where they light the lanterns,
Drink glasses of milk,
Then up postilion! and fly
To a singing of crickets
Under the stars of July.

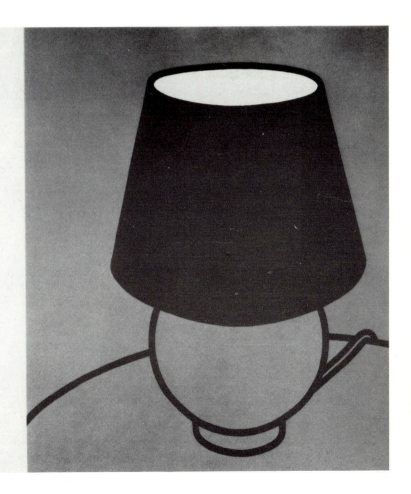

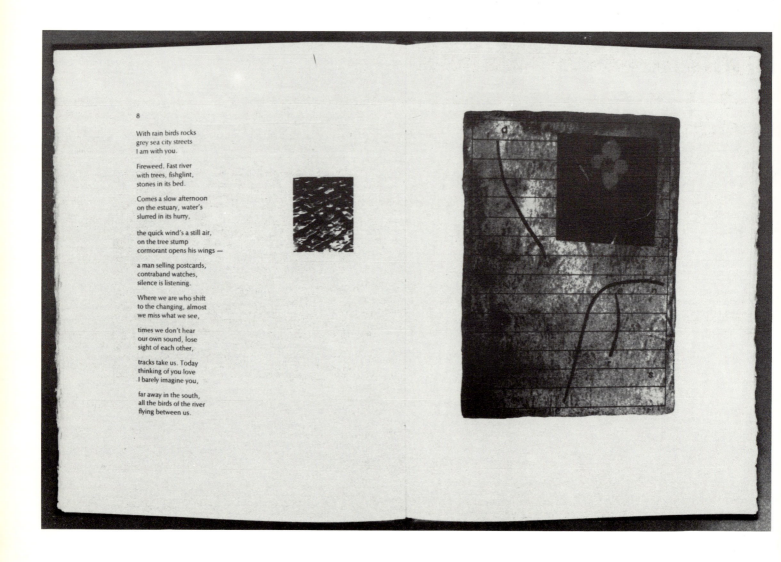

8

With rain birds rocks
grey sea city streets
I am with you.

Fireweed. Fast river
with trees, fishglint,
stones in its bed.

Comes a slow afternoon
on the estuary, water's
slurred in its hurry,

the quick wind's a still air,
on the tree stump
cormorant opens his wings —

a man selling postcards,
contraband watches,
silence is listening.

Where we are who shift
to the changing, almost
we miss what we see,

times we don't hear
our own sound, lose
sight of each other,

tracks take us. Today
thinking of you love
I barely imagine you,

far away in the south,
all the birds of the river
flying between us.

Peter Grimes

4

His efforts punish'd, and his food refused, —
Awake tormented, — soon aroused from sleep, —
Struck if he wept, and yet compell'd to weep,
The trembling boy dropp'd down and strove to pray,
Received a blow, and trembling turn'd away,
Or sobb'd and hid his piteous face, — while he,
The savage master, grinn'd in horrid glee:
He'd now the power he ever loved to show,
A feeling being subject to his blow.

Thus liv'd the lad, in hunger, peril, pain,
His tears despised, his supplications vain:
Compell'd by fear to lie, by need to steal,
His bed uneasy and unbless'd his meal,
For three sad years the boy his tortures bore,
And then his pains and trials were no more.
'How died he, Peter?' when the people said,
He growl'd — 'I found him lifeless in his bed';
Then tried for softer tone, and sigh'd,
 'Poor Sam is dead.'

Yet murmurs were there, and some questions ask'd, —
How he was fed, how punish'd, and how task'd?
Much they suspected, but they little proved,
And Peter pass'd untroubled and unmoved.
Another boy with equal ease was found,
The money granted, and the victim bound;
And what his fate? — One night it chanced he fell
From the boat's mast and perish'd in her well,
Where fish were living kept, and where the boy
(So reason'd men) could not himself destroy: —
'Yes! so it was,' said Peter, 'in his play,

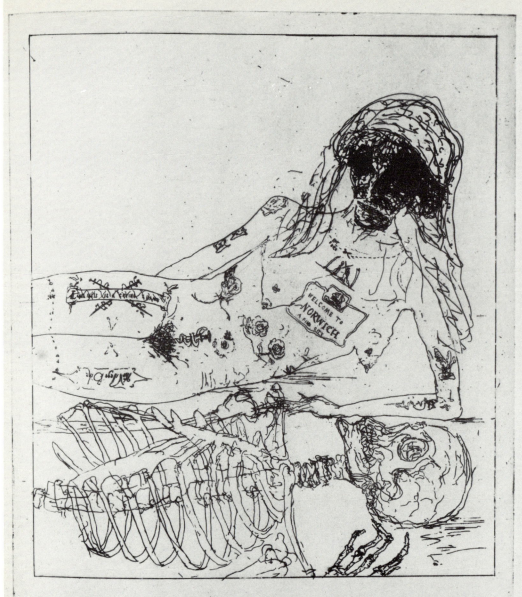

VERONICA GLEET

TATTOOIST AND SPIRITUALIST

When not dusting her first husband she consumes her lonely hours writing angry
letters to the Eastern Daily Press complaining of flatulence in the Assembly Rooms

13 Julia Farrer

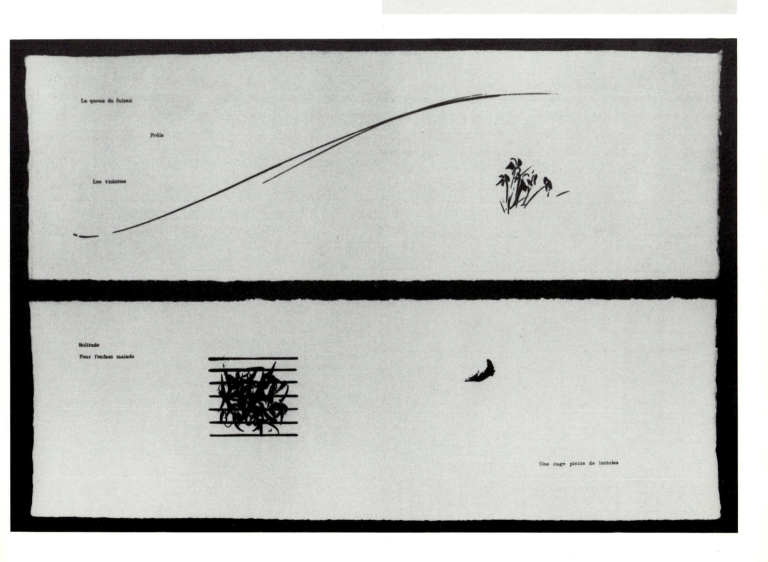

The Nun's Priest's Tale

Peck them right up, my dear, and swallow whole.
Be happy, husband, by your father's soul!
Don't be afraid of dreams. I'll say no more.'
'Madam,' he said, 'I thank you for your lore,
But with regard to Cato all the same,
His wisdom has, no doubt, a certain fame,
But though he said that we should take no heed
Of dreams, by God, in ancient books I read
Of many a man of more authority
Than ever Cato was, believe you me,
Who say the very opposite is true
And prove their theories by experience too.
Dreams have quite often been significations
As well of triumphs as of tribulations
That people undergo in this our life.
This needs no argument at all, dear wife,
The proof is all too manifest indeed.
'One of the greatest authors one can read
Says thus: there were two comrades once who went
On pilgrimage, sincere in their intent.
And as it happened they had reached a town
Where such a throng was milling up and down
And yet so scanty the accommodation,
They could not find themselves a habitation,
No, not a cottage that could lodge them both,
And so they separated, very loath,
Under constraint of this necessity
And each went off to find some hostelry,
And lodge whatever way his luck might fall.
'The first of them found refuge in a stall
Down in a yard with oxen and a plough.
His friend found lodging for himself somehow
Elsewhere, by accident or destiny,
Which governs all of us and equally.
'Now it so happened, long ere it was day,
This fellow had a dream, and as he lay
In bed it seemed he heard his comrade call,
"Help! I am lying in an ox's stall
And shall to-night be murdered as I lie.
Help me, dear brother, help or I shall die!
Come in all haste!" Such were the words he spoke,
The dreamer, lost in terror, then awoke.
But once awake he paid it no attention,
Turned over and dismissed it as invention,
It was a dream, he thought, a fantasy.
And twice he dreamt this dream successively.
'Yet a third time his comrade came again,
Or seemed to come, and said, "I have been slain.
Look, look! my wounds are bleeding wide and deep.
Rise early in the morning, break your sleep
And go to the west gate. You there shall see
A cart all loaded up with dung," said he,
"And in that dung my body has been hidden.
Boldly arrest that cart as you are bidden.
It was my money that they killed me for."
'He told him every detail, sighing sore,
And pitiful in feature, pale of hue.
This dream, believe me, Madam, turned out true;
For in the dawn, as soon as it was light,
He went to where his friend had spent the night
And when he came upon the cattle-stall
He looked about him and began to call.
'The innkeeper, appearing thereupon,
Quickly gave answer, "Sir, your friend has gone.
He left the town a little after dawn."
The man began to feel suspicious, drawn
By memories of his dream – the western gate,
The dung-cart – off he went, he would not wait,
Towards the western entry. There he found,
Seemingly on its way to dump some ground,
A dung-cart loaded on the very plan
Described so closely by the murdered man.
So he began to shout courageously
For right and vengeance on the felony,

'My friend's been killed! There's been a foul attack,
He's in that cart and gaping on his back!
Fetch the authorities, get the sheriff down
– Whoever job it is to run the town –
Help! My companion's murdered, sent to glory!"
'What need I add to finish off the story?
People ran out and cast the cart to ground,
And in the middle of the dung they found
The murdered man. The corpse was fresh and new.
'O blessed God, that art so just and true,
Thou thou revealest murder! As we say,
"Murder will out." We see it day by day.
Murder's a foul, abominable treason,
So loathsome to God's justice, to God's reason,
He will not suffer its concealment. True,
Things may be hidden for a year or two,
But still "Murder will out", that's my conclusion.
'All the town officers in great confusion
Seized on the carter and they gave him hell,
And then they racked the innkeeper as well,
And both confessed. And thus they took the wrecks
And there and then they hanged them by their necks.
'By this we see that dreams are to be dreaded.
And in the self-same book I find embedded,
Right in the very chapter after this
(I'm not inventing, as I hope for bliss)
The story of two men who started out
To cross the sea – for merchandise no doubt –
But as the winds were contrary they waited.
It was a pleasant town, I should have stated,
Merrily grouped about the haven-side.
A few days later with the evening tide
The wind veered round so as to suit them best;
They were delighted and they went to rest
Meaning to sail next morning early. Well,
To one of them a miracle befell.
'This man as he lay sleeping, it would seem,
Just before dawn had an astounding dream.
He thought a man was standing by his bed
Commanding him to wait, and thus he said:
"If you set sail to-morrow as you intend
You will be drowned. My tale is at an end."
'He woke and told his friend what had occurred
And begged him that the journey be deferred
At least a day, implored him not to start.
But his companion, lying there apart,
Began to laugh and treat him to derision.
"I'm not afraid," he said, "of any vision,
To let it interfere with my affairs;
A straw for all your dreamings and your scares.
Dreams are just empty nonsense, merest japes;
Why, people dream all day of owls and apes,
All sorts of trash that can't be understood,
Things that have never happened and never could.
But as I see you mean to stay behind
And miss the tide for wilful sloth of mind
God knows I'm sorry for it, but good day!"
And so he took his leave and went his way.
'And yet, before they'd covered half the trip
– I don't know what went wrong – there was a rip
And by some accident the ship went down,
Her bottom rent, all hands aboard to drown
In sight of all the vessels at her side,
That had put out upon the self-same tide.
'So, my dear Pertelote, if you discern
The force of these examples, you may learn
One never should be careless about dreams,
For, undeniably, I say it seems
That many are a sign of trouble breeding.
'Now, take St Kenelm's life which I've been reading;
He was Kenulphus' son, the noble King
Of Mercia. Now, St Kenelm dreamt a thing

86

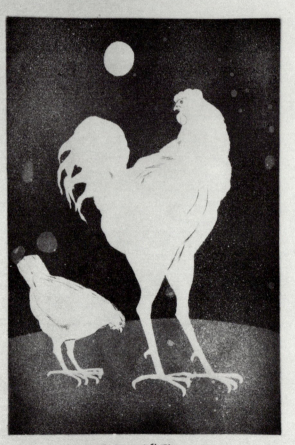

The Nun priest's Tale.
This gentle cock up master in some measure
Of seven hens, all there to do his pleasure
They were his sisters and his paramours,
Coloured like him in all particulars;
She with the loveliest dyes upon her throat
Was known as gracious Lady Pertelote,
Courteous she was, discreet and debonair,
Companionable too, and took such care
In all her manners, since she was seven days old.
She held the heart of Chanticleer controlled,
Locked up securely in her every limb.

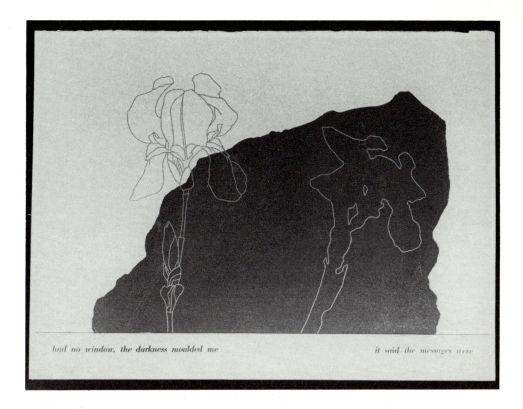

had no window, the darkness moulded me *it said the messages were*

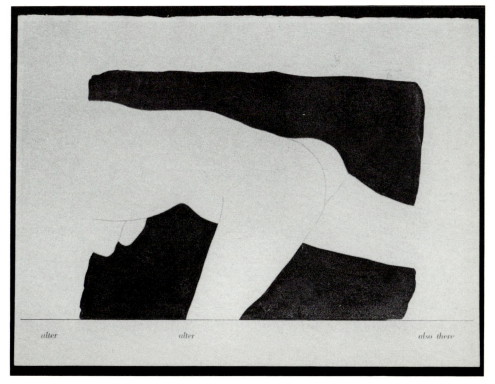

alter *alter* *also there*

frowned upon by the Cahors wine inspectors, and his wine has never been the same. Since his wife died he has pulled up most of his vines, keeping just enough for his own use.

As councillor, Leo (with his wife) was responsible for many decisions. He and the late mayor erected a war memorial, removed the cemetery and built another a little way from the village. They also enlarged the village square and built a new vicarage, convinced that given a modern villa a priest would once again live in the village; but no priest will ever live in Le Boulvé, or any small parish, again. The abbés are all grouped together in nearby towns, and visit their parishes at appropriate times.

Foissac

The former mayor lived in a hamlet called Foissac. The signpost he had put up pointing there has been painted over by some wit, and replaced with 'Germany, 1 km.' At the end of the War, several German prisoners were in Le Boulvé, and one of them married the Mayor's daughter; in fact, out of the five prisoners three settled down and married local girls. They are all hard workers and are much liked. The mayor's son-in-law is now proud of his *vin de Cahors, appellation contrôlée*.

82

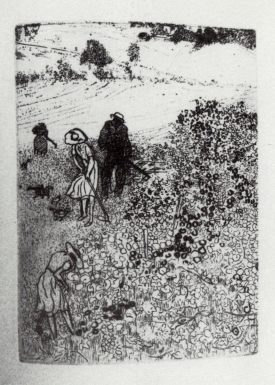

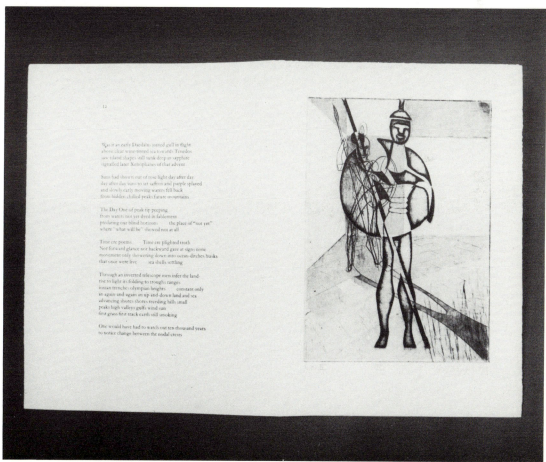

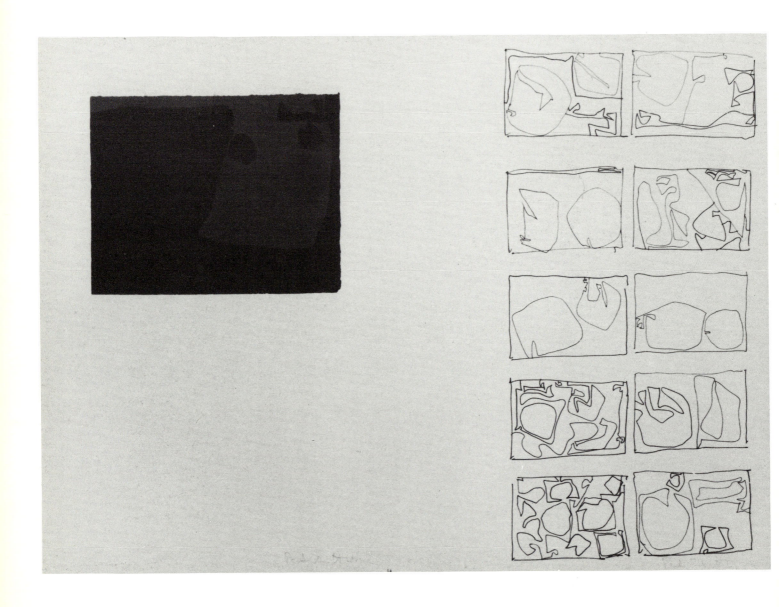

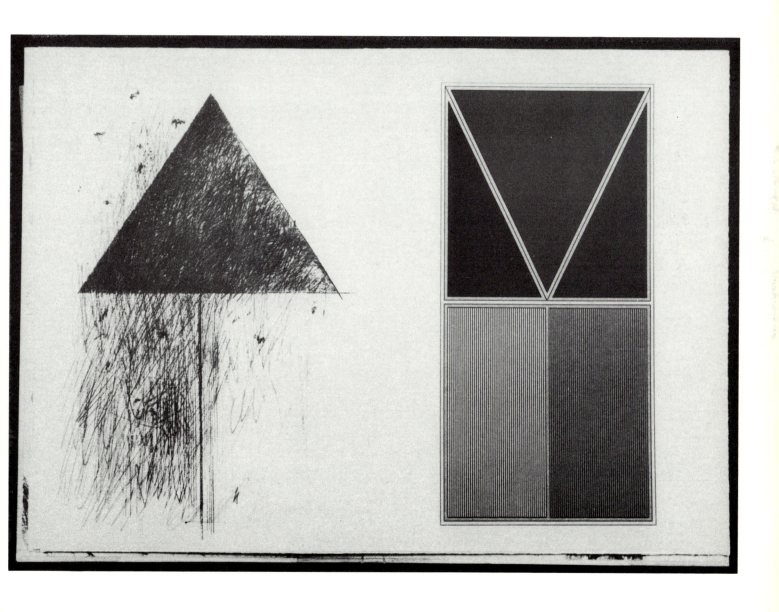

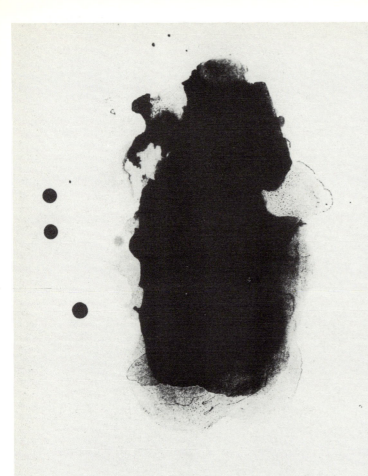

THE ANNUNCIATION

The angel and the girl are met.
Earth was the only meeting place.
For the embodied never yet
Travelled beyond the shore of space.
The eternal spirits in freedom go.

See, they have come together, see,
While the destroying minutes flow,
Each reflects the other's face
Till heaven in hers and earth in his
Shine steady there. He's come to her
From far beyond the farthest star,
Feathered through time. Immediacy

Of strangest strangeness is the bliss
That from their limbs all movement takes.
Yet the increasing rapture brings
So great a wonder that it makes
Each feather tremble on his wings.

Outside the window footsteps fall
Into the ordinary day
And with the sun along the wall
Pursue their unreturning way.
Sound's perpetual roundabout
Rolls its numbered octaves out
And hoarsely grinds its battered tune.

But through the endless afternoon
These neither speak nor movement make,
But stare into their deepening trance
As if their gaze would never break.

21 William Johnstone

Scop Hwilum Sang

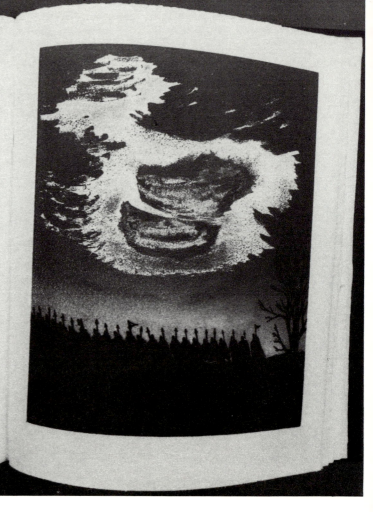

Then was a host of the valiant made ready,
men brave in battle, courageous warriors
and companions, they went forth, bore banners
of victory, marched straight on to the fight,
heroes beneath their helmets, from the holy city
at the very dawn of day; shields rang, resounded
loudly. At that, the lean wolf in the wood rejoiced
and the dark raven, the bird greedy for slaughter,
both knew that the warriors were minded
to prepare for them a feast of doomed men.
And behind them flew the eagle, dewy-feathered,
eager for food; dark-coated, horny-beaked,
he sang a song of war. The warriors marched on,
men ready for battle, armed with shields
of hollow linden - those who in former times
had suffered the insults of the foreigners, the taunt
of the heathen ones. For that the Assyrians
were all ruthlessly repaid in the spear-play,
when the Hebrews under their banners
had come upon their war camp. Boldly they shot
forth showers of arrows, serpents of war
from their horn bows, unwavering shafts.
Loudly shouted the fierce warriors, cast spears
into the throng of cruel ones; angry were those
native to the land against the hateful race.
Without fear they came, stout of heart,
they harshly aroused their ancient foe
overpowered as they were with mead.

Þā wearð snelra werod snūde gegearewod,
cēnra tō campe; stōpon cynerōfe
secgas and gesīðas, bǣron [sige]þūfas,
fōron tō gefeohte forð on gerihte,
hæleð under helmum of þǣre hāligan byrig
on ðæt dægred sylf; dynedan scildas,
hlūde hlummon. Þæs se hlanca gefeah
wulf in walde, and se wanna hrefn,
wælgīfre fugel: wiston bēgen
þæt him ðā þēodguman þōhton tilian
fylle on fǣgum; ac him flēah on lāst
earn ǣtes georn, ūrigfeðera,
salowigpāda sang hildelēoð,
hyrnednebba. Stōpon heaðorincas,
beornas tō beadowe bordum beðeahte,
hwealfum lindum, þā ðe hwīle ǣr
elðēodigra edwit þoledon,
hǣðenra hosp; him þæt hearde wearð
æt ðām æscplegan eallum forgolden
Assyrium, syððan Ebrēas
under gūðfanum gegān hæfdon
tō ðām fyrdwīcum. Hīe ðā fromlīce
ē ton forð flēogan flāna scūras,
[hilde]nǣdran of hornbogan,
strǣlas stedehearde; styrmdon hlūde
grame gūðfrecan, gāras sendon
in heardra gemang; hæleð wǣron yrre,
landbūende lāðum cynne,
stōpon styrnmōde, stercedferhðe
wrehton unsōfte ealdgenīðlan
medowērige.

Art Scribe 5 and 7
Interesting argument between David Sweet &
Jeff Steele — Core and Boundary.
David Sweet attempting to justify painting painting
and Jeff arguing — for rational art fed by ideas
from the outside — from the social order I reject
Painting painting prolongs the mystical —
an order which sustains the present exploiters
The order which Jeff promotes is non hierarchic
and non mystical.

July 16th
 I am interested in the gap between
natural number — in the flow, if you like,
from one number to the next. The wavy grid
seemed one way to suggest this notion — elastic
transition — one form into another — elastic
seems like another.

July 28th
 Ken Martin — Mary filled a baking tin with plaster
and carried her first relief. Since Mary was into
making reliefs I had to do something else.
Movement. I started making mobiles.
Biderman " A.r in Revolution " 1953 — Ceri Richards
had a copy: gave it to Passmore because he could not
understand it. Passmore could not either.

 I went to Paris 20th – 24th while reading TJ Clark
on Courbet. Spent day in Louvre looking at the
Funeral at Ornan and the Artist in his Studio — in relation

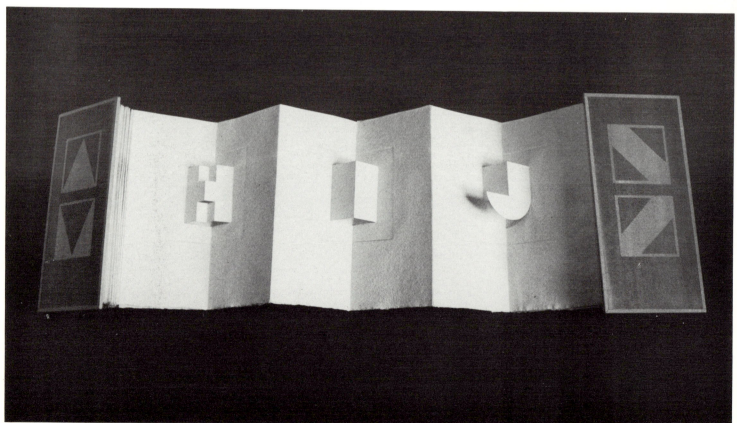

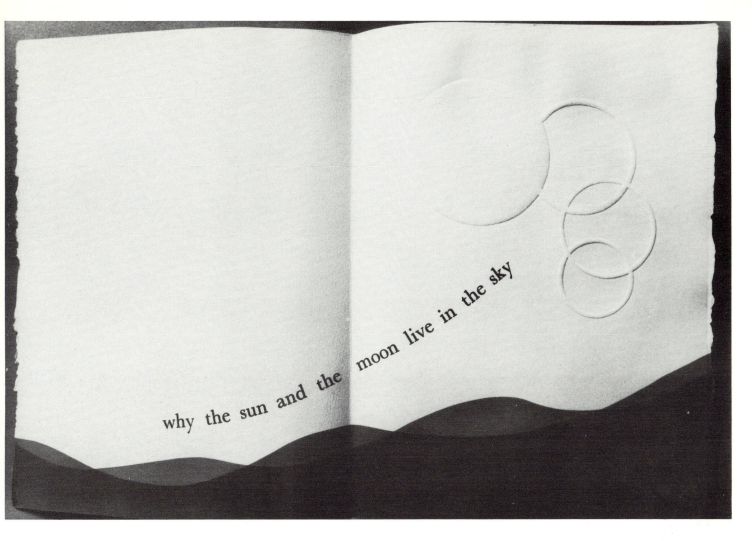

why the sun and the moon live in the sky

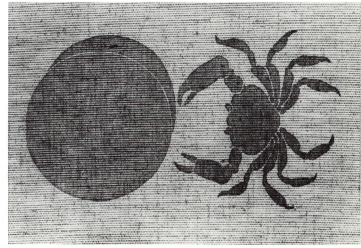

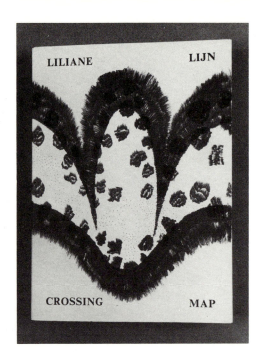

Three Candles

Three Faces

Three Natives

Sometimes after midnight
if you listen with attention
you can hear, besides the sound of
 clocks ticking
 faucets dripping
 flies dying
 and tea steeping,
the sound of
candles burning
mists rising
fogs settling
and dust accumulating under the bed.
You can hear, besides the sound of
 walls warping
 beams sagging
 joints parting
 and the roof leaking,
the sound of
paint peeling
paper fading
carpets thinning
and stuffing coming out of pillows.
You can hear, besides the sound of
 seams splitting
 buttons popping
 nylons running
 and shoe leather wearing,
the sound of
collars fraying
moths chewing
sweaters ravelling
and zippers losing their teeth.
You can hear, besides the sound of
 cups chipping
 plates cracking
 pots breaking
 and spoons rusting,
the sound of
beer flattening
wine turning
milk souring
bread molding
lemons shrivelling
anemones wilting
and the small steady sound
of the disintegration of your body.

29 Mary Jo Major

Either of these is in thy lot,
Samson, with might endu'd
Above the Sons of men; but sight bereav'd
May chance to number thee with those
Whom Patience finally must crown.
This Idols day hath bin to thee no day of rest,
 Labouring thy mind
More then the working day thy hands,
And yet perhaps more trouble is behind.
For I descry this way
Some other tending, in his hand
A Scepter or quaint staff he bears,
Comes on amain, speed in his look.
By his habit I discern him now
A Public Officer, and now at hand.
His message will be short and voluble.
 Off. *Ebrews*, the Pris'ner *Samson* here I seek.
 Chor. His manacles remark him, there he sits.
 Off. Samson, to thee our Lords thus bid me say;
This day to *Dagon* is a solemn Feast,
With Sacrifices, Triumph, Pomp, and Games;
Thy strength they know surpassing human rate,
And now some public proof thereof require
To honour this great Feast, and great Assembly;
Rise therefore with all speed and come along,
Where I will see thee heartn'd and fresh clad
To appear as fits before th' illustrious Lords.
 Sam. Thou knowst I am an *Ebrew*, therefore tell them,
Our Law forbids at thir Religious Rites
My presence; for that cause I cannot come.
 Off. This answer, be assur'd, will not content them.
 Sam. Have they not Sword-players, and ev'ry sort

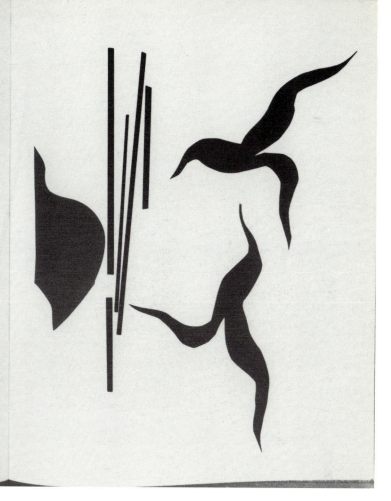

30 Robert Medley

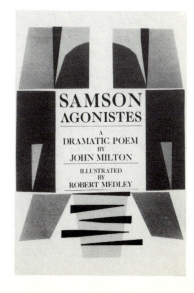

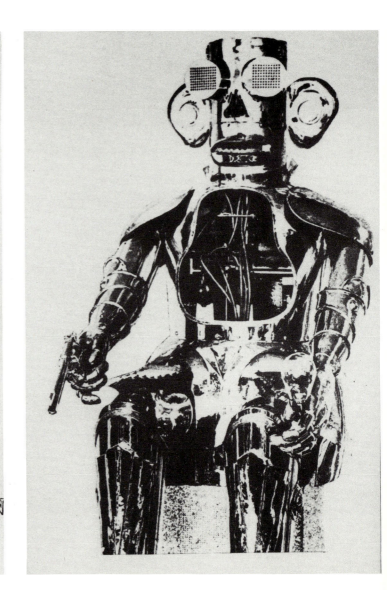

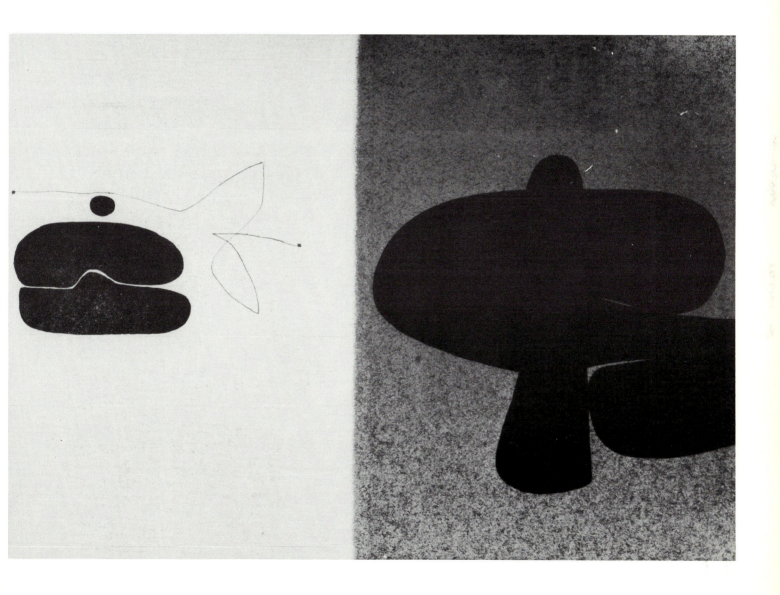

Then, having rounded off his speech, the thief
shot up both hands and made the sign of figs
and shouted, 'Take that, God! So much for you!'
From that time on I counted snakes my friends
for one of them was coiling round his neck
as if to say, 'That's how to shut your mouth!'
Another bound his arms up once again
and locked itself in front with such a grip
he couldn't even twitch them any more.
Pistoia, ah Pistoia, end it all!
Why not resolve to burn yourself to ash
since you outclass your ancestors in crime?
Through all these dingy rings of hell I'd seen
no soul who treated God with such disdain,
not even he who fell from the walls of Thebes.
Without another word he bolted off.
Just then I saw a centaur wild with rage
come yelling, 'Where's the hardened one? Where's he?'
Maremma cannot boast I think more snakes
than clustered up his spine to where our form
begins to show. And in the cleft between
his shoulder blades a dragon, wings outstretched,
set fire to anyone that crossed its path.
'That's Cacus,' said my guide, 'who frequently
beneath the rock-face of Mount Aventine
made lakes of blood. He doesn't share the road
his brothers tread, because by fraud he robbed
his neighbour of the celebrated herd.
Such crooked actions found their end beneath
the club of Hercules, which struck perhaps
a hundred blows though barely ten were felt.'
Then, while he spoke, the creature galloped past.
Below us at that moment came three shades
whom I should not have noticed, nor my guide,
had they not shouted, 'Who are you?', at which
we stopped our talk and occupied ourselves
with them alone: they were unknown to me.
But it so happened as it often does
that one of them by chance had cause to name
another, 'Where's Cianfa got to now?'
And so I placed my finger, chin to nose,
to make my guide attend to what was said.
If, reader, you're reluctant to believe
what I'm about to tell, it's no surprise
since I who saw can scarcely credit it.
For all at once, while I was watching them,
a six-legged snake shot up in front of one
and clung to him: its grip was everywhere.
It clasped his belly with its middle feet
and clamped its forelegs tight about his arms
then sank its fangs in both his cheeks in turn;
then, splaying out its hind legs on his thighs,

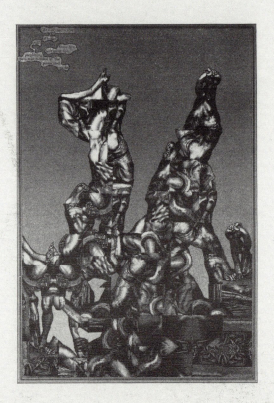

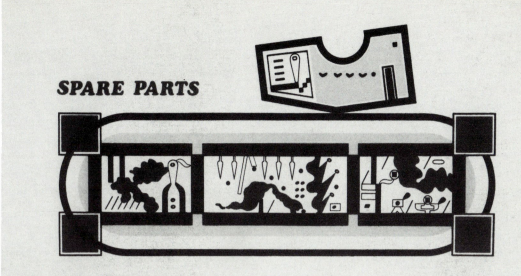

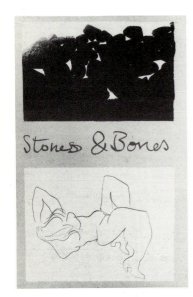

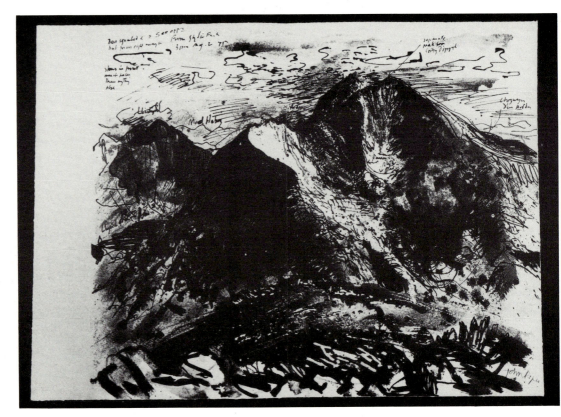

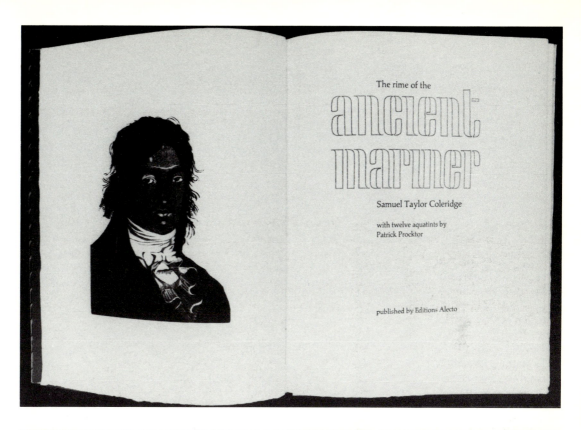

The rime of the

ancient mariner

Samuel Taylor Coleridge

with twelve aquatints by
Patrick Procktor

published by Editions Alecto

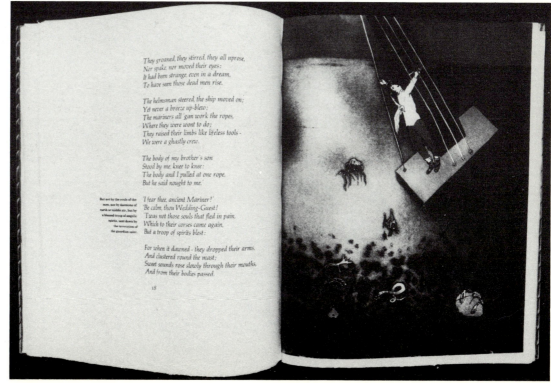

They groaned, they stirred, they all uprose,
Nor spake, nor moved their eyes;
It had been strange, even in a dream,
To have seen those dead men rise.

The helmsman steered, the ship moved on;
Yet never a breeze up-blew;
The mariners all 'gan work the ropes,
Where they were wont to do;
They raised their limbs like lifeless tools -
We were a ghastly crew.

The body of my brother's son
Stood by me, knee to knee:
The body and I pulled at one rope,
But he said nought to me.

But not by the souls of the men, nor by daemons of earth or middle air, but by a blessed troop of angelic spirits, sent down by the invocation of the guardian saint.

'I fear thee, ancient Mariner!'
'Be calm, thou Wedding-Guest!
'Twas not those souls that fled in pain,
Which to their corses came again,
But a troop of spirits blest:

For when it dawned - they dropped their arms,
And clustered round the mast;
Sweet sounds rose slowly through their mouths,
And from their bodies passed.

18

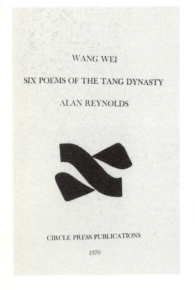

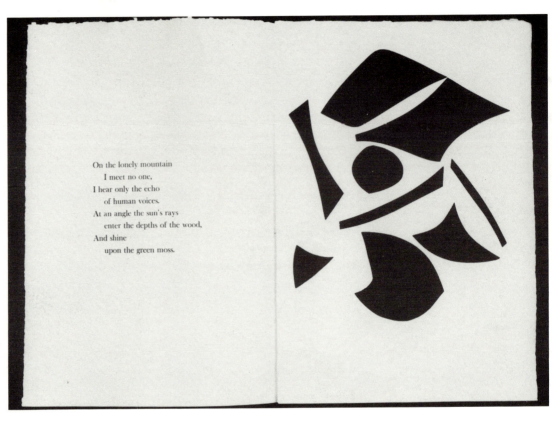

THE SUN RISING

Busy old fool, unruly sun,
Why dost thou thus
Through windows and through curtains call on us?
Must to thy motions lovers' seasons run?
Saucy pedantic wretch, go chide
Late schoolboys and sour prentices;
Go tell court huntsmen that the king will ride;
Call country ants to harvest offices.
Love, all alike, no season knows nor clime,
Nor hours, days, months, which are the rags of time.

Thy beams, so reverend and strong
Why shouldst thou think?
I could eclipse and cloud them with a wink,
But that I would not lose her sight so long.
If her eyes have not blinded thine
Look, and tomorrow late tell me
Whether both th'Indias of spice and mine
Be where thou leftst them or lie here with me.
Ask for those kings whom thou saw'st yesterday,
And thou shalt hear all here in one bed lay.

She is all states, and all princes I,
Nothing else is.
Princes do but play us; compared to this
All honour's mimic, all wealth alchemy.
Thou sun art half as happy as we,
In that the world's contracted thus;
Thine age asks ease, and since thy duties be
To warm the world, that's done in warming us.
Shine here to us and thou art everywhere;
This bed thy centre is, these walls thy sphere.

Donne

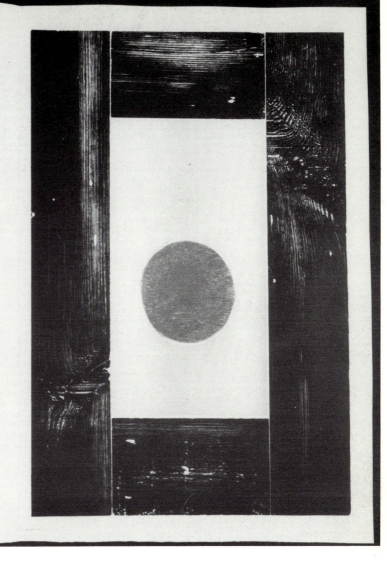

38 Michael Rothenstein

THE TAO OF WATER

Poem by James Kirkup with prints by Birgit Skiöld
CIRCLE PRESS 1979

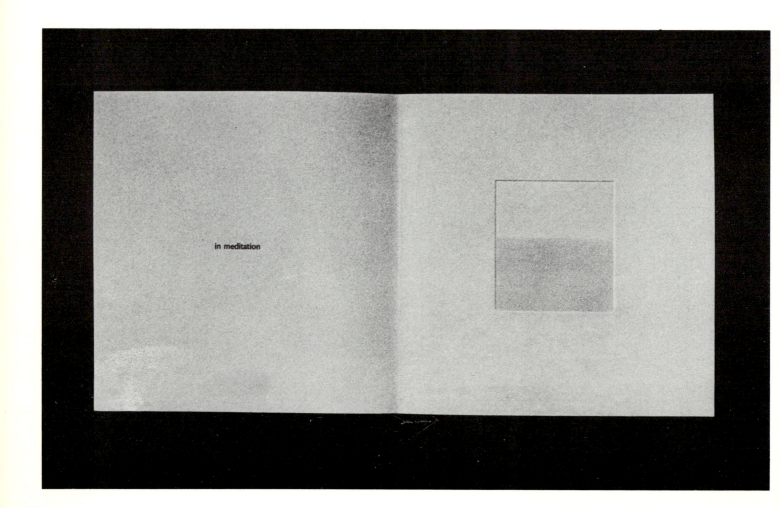

in meditation

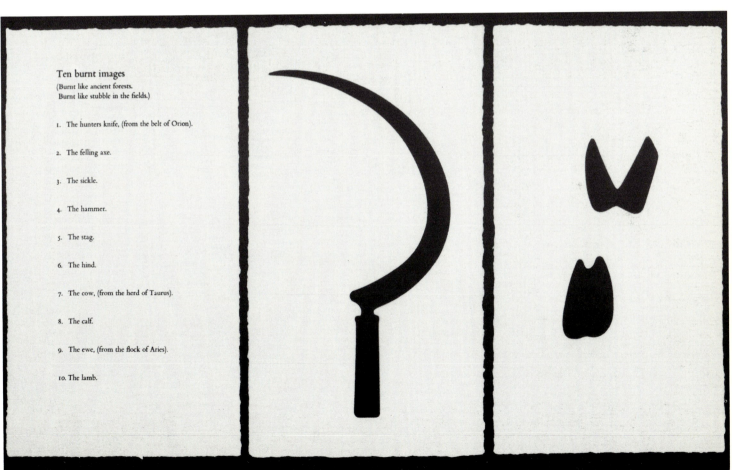

Ten burnt images
(Burnt like ancient forests.
Burnt like stubble in the fields.)

1. The hunters knife, (from the belt of Orion).

2. The felling axe.

3. The sickle.

4. The hammer.

5. The stag.

6. The hind.

7. The cow, (from the herd of Taurus).

8. The calf.

9. The ewe, (from the flock of Aries).

10. The lamb.

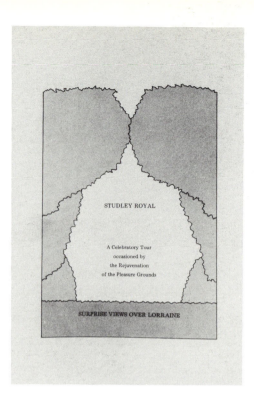

STUDLEY ROYAL

A Celebratory Tour
occasioned by
the Rejuvenation
of the Pleasure Grounds

SURPRISE VIEWS OVER LORRAINE

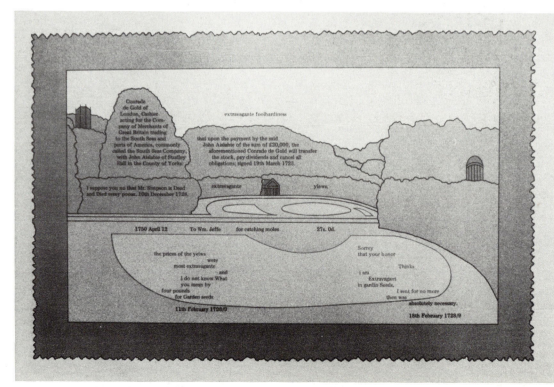

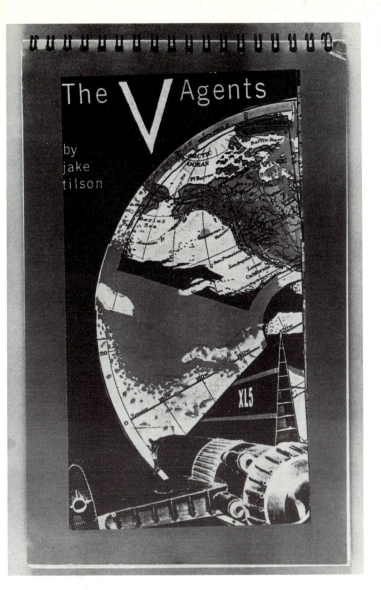

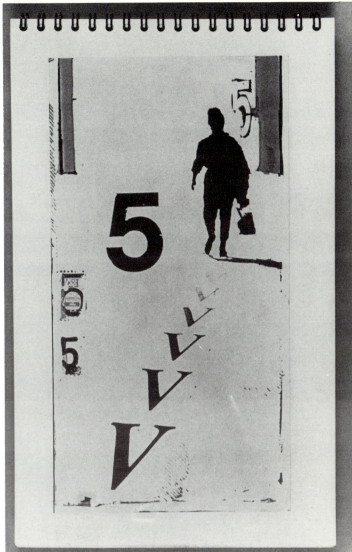

42 Jake Tilson

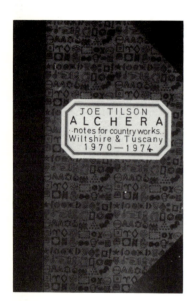

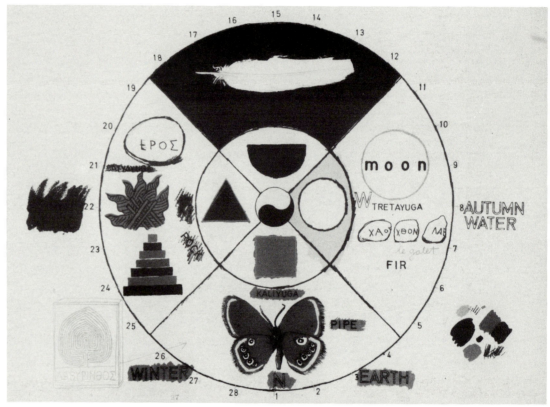

we go on. thinking we know. they stand still. telling us we don't. stubborn. telling us we know we don't. they don't shout. they don't have to. we're empty & the sound carries.

they do not raise their voices. not that *that* of itself matters. since we can't understand what they say. they do change colors. they do so without us seeing. & even if we had what could we have said.

you might find a lamp, a bottle, a pot. you'd always find numbers. maybe they carry a face on their reverse side. like coins. the faces are part of the story. anyway. the numbers make a progression. like ten green bottles. the progression leads nowhere. it's a spreading of feeling. the other side of man's face in a time of greed.

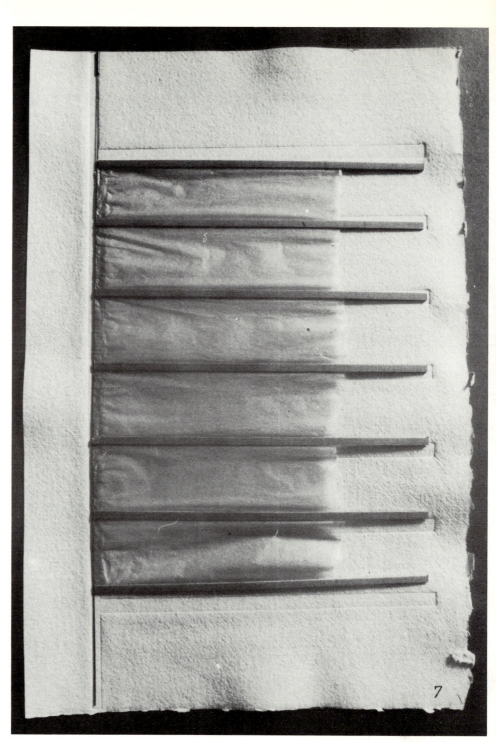